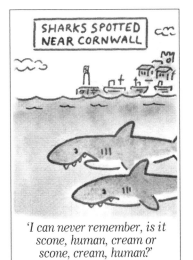

'I can never remember, is it
scone, human, cream or
scone, cream, human?'

THE BEST OF
MATT
2018

MATTHEW PRITCHETT

studied at St Martin's School of Art in London and first saw himself published in the *New Statesman* during one of its rare lapses from high seriousness. He has been the *Daily Telegraph*'s front-page pocket cartoonist since 1988. In 1995, 1996, 1999, 2005, 2009 and 2013 he was the winner of the Cartoon Arts Trust Award and in 1991, 2004 and 2006 he was 'What the Papers Say' Cartoonist of the Year. In 1996, 1998, 2000, 2008 and 2009 he was the *UK Press Gazette* Cartoonist of the Year and in 2015 he was awarded the Journalists' Charity Award. In 2002 he received an MBE.

Also available, *30 Years of Matt*

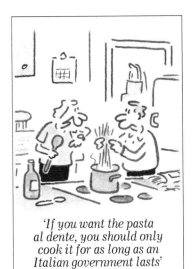

'If you want the pasta al dente, you should only cook it for as long as an Italian government lasts'

The Daily Telegraph

THE BEST OF

MATT

2018

ORION

An Orion Paperback

First published in Great Britain in 2018 by Orion Books
A division of the Orion Publishing Group Ltd
Carmelite House
50 Victoria Embankment
London
EC4Y 0DZ

A Hachette UK Company

10 9 8 7 6 5 4 3 2 1

The right of Matthew Pritchett to be identified as the author
of this work has been asserted in accordance with the
Copyright, Designs and Patents Act 1988.

A CIP catalogue record for this book is available from the British Library.

ISBN: 978 1 4091 6465 4

Printed in the UK by CPI Group (UK) Ltd, Croydon, CR0 4YY

The Orion Publishing Group's policy is to use papers that are natural,
renewable and recyclable products and made from wood grown in
sustainable forests. The logging and manufacturing processes are
expected to conform to the environmental regulations of the country
of origin.

www.orionbooks.co.uk

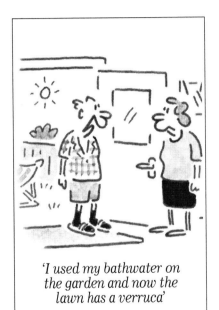

'I used my bathwater on the garden and now the lawn has a verruca'

THE BEST OF
MATT
2018

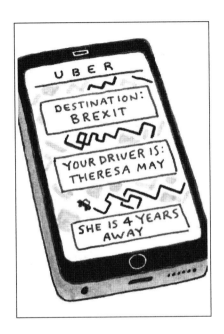

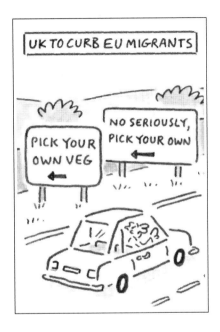

Brexit

'The EU wants to wreck Brexit, but we're taking back control and doing it ourselves'

'There was give and take on both sides. We agreed to pay a divorce bill, but I came away with Mr Barnier's pen'

'It causes more rows than
Monopoly, and lasts longer
than a 1,000 piece jigsaw'

'It's good news for our
anti-obesity campaign.
We won't be having our cake
and we won't be eating it'

'Ice cream? No, this is
Philip Hammond's
ministerial car'

'While we work on our Brexit
forecast, this man will play
some very sad music'

Hammond blamed for being a Remoaner

'And England scored
458 runs, despite Brexit'

'My family have been
rebelling in the Lords for
generations. I'm a hereditary
pain-in-the-backside'

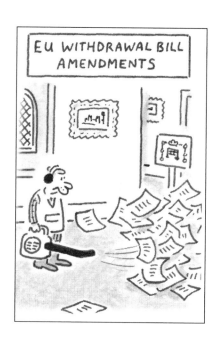

EU WITHDRAWAL BILL AMENDMENTS

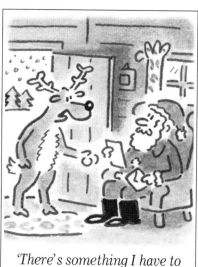

'There's something I have to tell you. The 58 Brexit impact assessments don't really exist'

'I'm on the Brexit diet. I fast on days when Labour back Brexit, and eat normally on days when they oppose it'

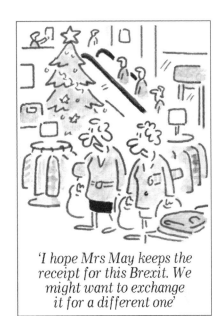

'I hope Mrs May keeps the receipt for this Brexit. We might want to exchange it for a different one'

'Apparently, the British government has 33 different words for a customs union'

'This one's powerful enough to suck the UK out of the customs union'

'I'm running the Marathon
as a hard Irish border to
raise awareness of the issue'

'Distinguishing features:
absolutely livid'

'They can deliver our new
passports when they
come here to catch our fish'

Passports made in France

'Here is your lovely blue
passport. That will be four
shillings and thruppence'

'To be frank, this was
one of my red lines'

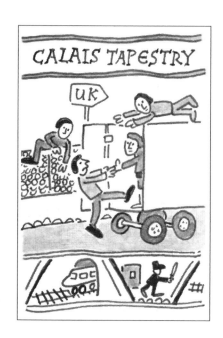

Bayeux Tapestry to UK

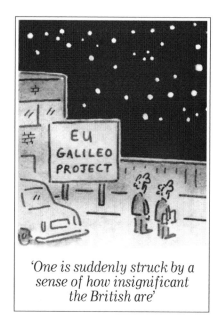

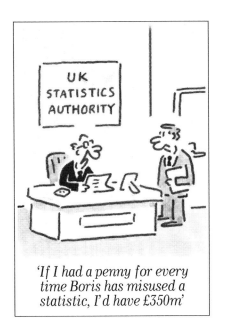

'If I had a penny for every time Boris has misused a statistic, I'd have £350m'

'A doctor will see you as soon as the NHS starts receiving the weekly £350m Brexit cash'

Brexit

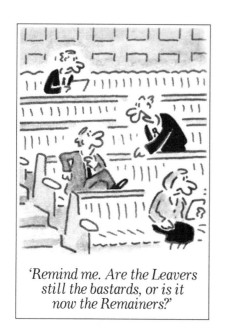

'Remind me. Are the Leavers
still the bastards, or is it
now the Remainers?'

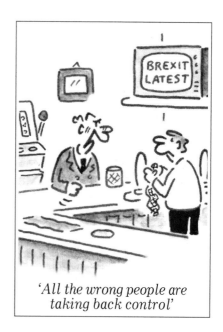

'All the wrong people are
taking back control'

'Thank you for calling the EU. Unfortunately nobody is available to reject your customs plan. Your call is not important to us'

'Dear John,
I'm leaving you while remaining closely aligned in most areas.
Home around 6.
Mary'

'I met Corbyn. He told me his runner beans are doing well and he might plant some courgettes'

Corbyn's Eastern European links

'Letters on parchment, catchy lute music and a Latin dictionary. We've found Rees-Mogg's leadership campaign HQ'

'A question from a
Mr McDonnell: "What
should I do if my magic
tree gets leaf blight?"'

'I think we've reached
peak Corbyn'

Local elections

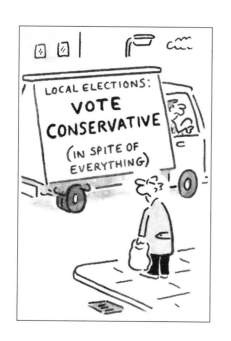

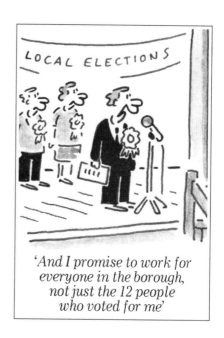

Local elections

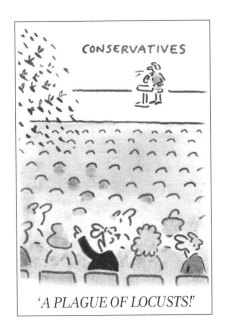

May's disastrous conference speech

Politics

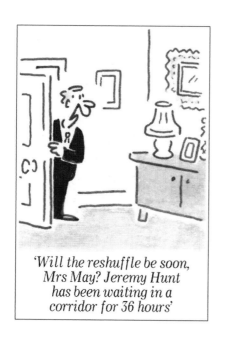

'Will the reshuffle be soon, Mrs May? Jeremy Hunt has been waiting in a corridor for 36 hours'

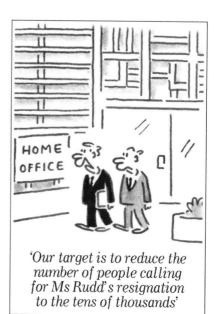

'Our target is to reduce the number of people calling for Ms Rudd's resignation to the tens of thousands'

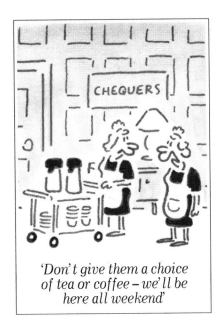

'Don't give them a choice
of tea or coffee – we'll be
here all weekend'

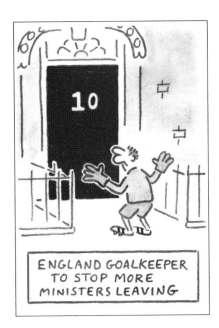

ENGLAND GOALKEEPER
TO STOP MORE
MINISTERS LEAVING

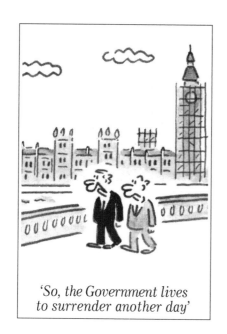

'So, the Government lives
to surrender another day'

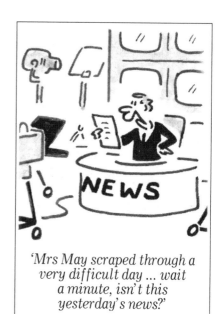

'Mrs May scraped through a
very difficult day ... wait
a minute, isn't this
yesterday's news?'

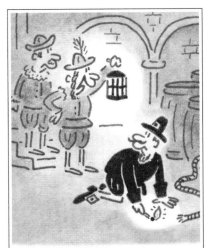

'Oh thank goodness! We heard that someone was behaving inappropriately down here'

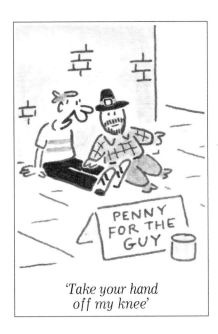

'Take your hand off my knee'

Westminster Sex Scandal

*'I'll be honest, there may
be more revelations
about me to come'*

'I have an offshore account
to stop the taxman
groping my money'

'Stop talking about Brexit.
It's not light-hearted banter
and it's inappropriate'

Trump

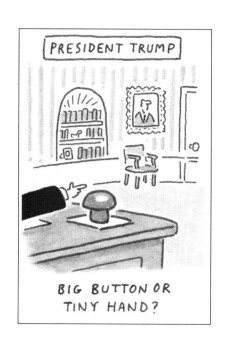

BIG BUTTON OR TINY HAND?

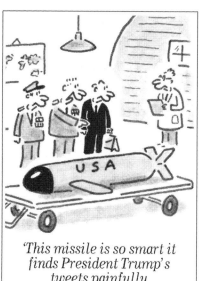

'This missile is so smart it finds President Trump's tweets painfully embarrassing'

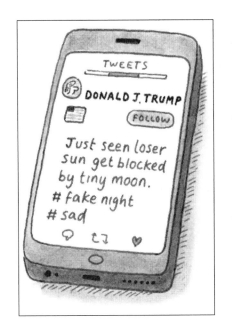

Eclipse

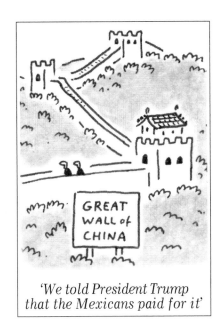

Trump

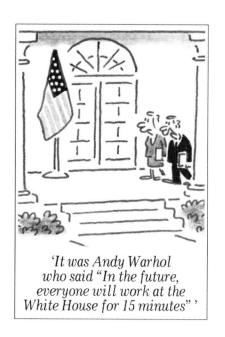

'It was Andy Warhol
who said "In the future,
everyone will work at the
White House for 15 minutes"'

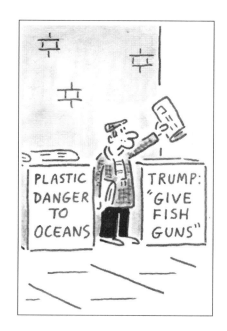

PLASTIC
DANGER
TO
OCEANS

TRUMP:
"GIVE
FISH
GUNS"

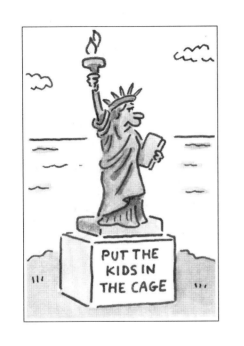

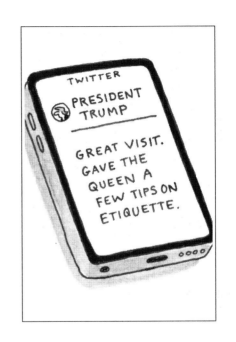

Plastic

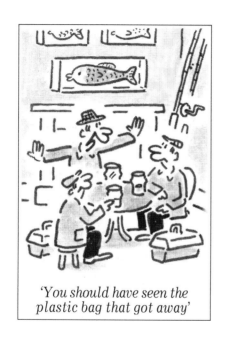

'You should have seen the plastic bag that got away'

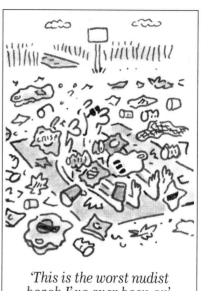

'This is the worst nudist beach I've ever been on'

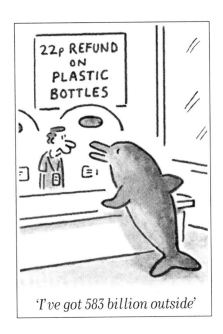

'I've got 583 billion outside'

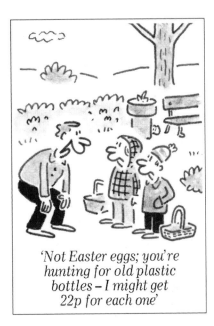

'Not Easter eggs; you're hunting for old plastic bottles – I might get 22p for each one'

Plastic

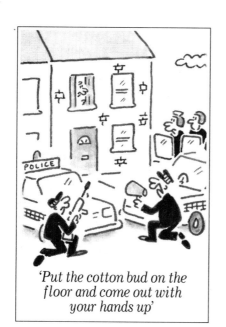

'Put the cotton bud on the floor and come out with your hands up'

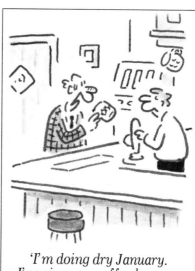

'I'm doing dry January. I've given up coffee because disposable cups are so harmful'

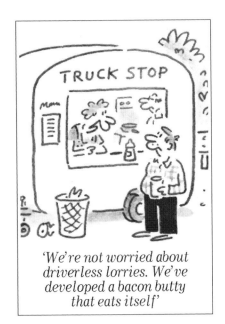

'We're not worried about driverless lorries. We've developed a bacon butty that eats itself'

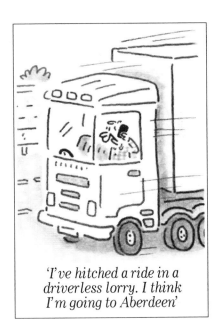

'I've hitched a ride in a driverless lorry. I think I'm going to Aberdeen'

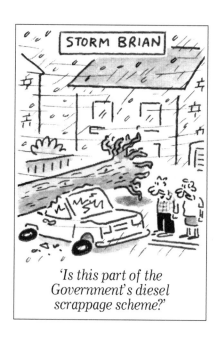

'Is this part of the
Government's diesel
scrappage scheme?'

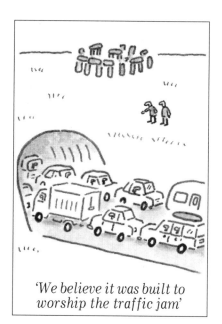

'We believe it was built to
worship the traffic jam'

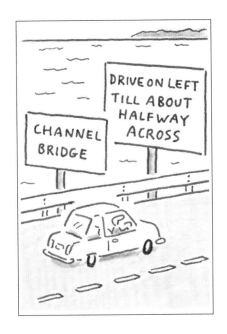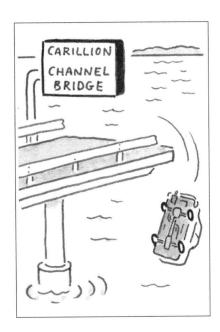

Boris's Channel bridge

'The gallery has acquired this very valuable piece. It's titled "Swindon to London Season Ticket"'

'Cheese sandwich? It's cheaper if you buy the bread here and get the cheese at the next station'

'I'm on the train.
Sell the car and bring
the money to the station'

'Daddy, can we cancel a
toboggan ride due to
adverse weather'

'I'm just saying, we could use some extra space round here to land'

'I SAID, THERE'S A DEAFENING SILENCE FROM BORIS OVER THE NEW RUNWAY'

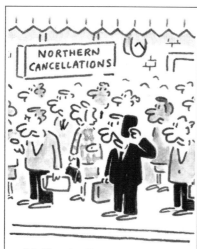

'Hello, darling, I'm coming home by train. You should re-marry and try to forget me'

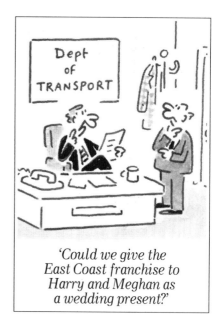

'Could we give the East Coast franchise to Harry and Meghan as a wedding present?'

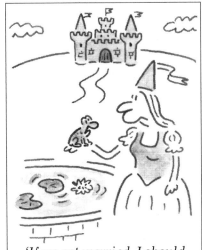

'If we get married, I should warn you, I have a huge extended family'

'It's President Trump. Can he have Mr Markle's wedding invitation?'

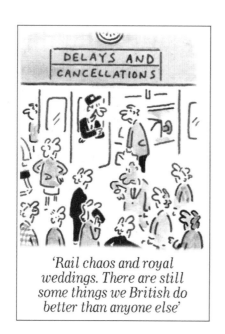

'Rail chaos and royal weddings. There are still some things we British do better than anyone else'

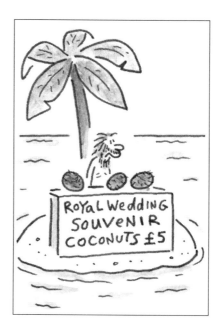

ROYAL WEDDING SOUVENIR COCONUTS £5

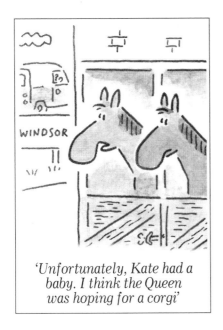

'Unfortunately, Kate had a baby. I think the Queen was hoping for a corgi'

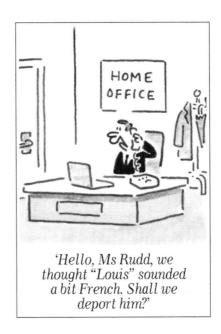

'Hello, Ms Rudd, we thought "Louis" sounded a bit French. Shall we deport him?'

Royal baby

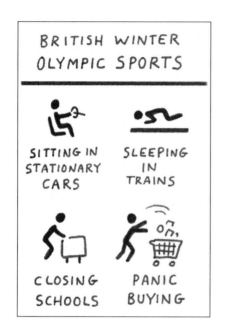

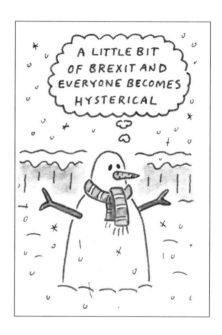

Weather chaos

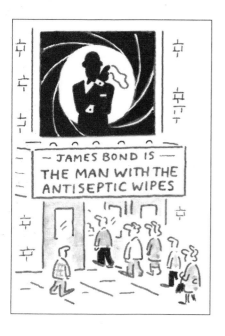

Government's first response

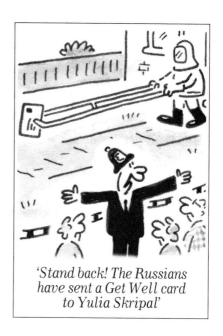

'Stand back! The Russians have sent a Get Well card to Yulia Skripal'

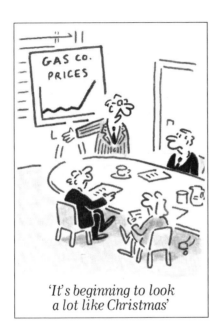

'It's beginning to look
a lot like Christmas'

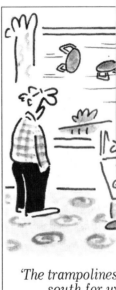

'The trampolines
south for w

Skripal Poisoning

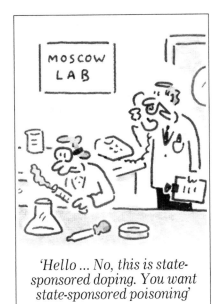

'Hello ... No, this is state-sponsored doping. You want state-sponsored poisoning'

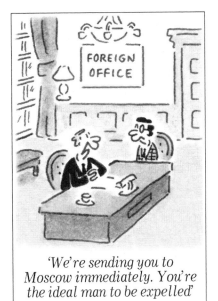

'We're sending you to Moscow immediately. You're the ideal man to be expelled'

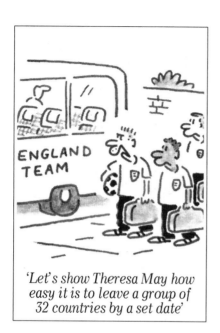

'Let's show Theresa May how easy it is to leave a group of 32 countries by a set date'

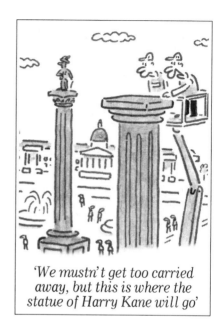

'We mustn't get too carried away, but this is where the statue of Harry Kane will go'

Pessimism turns to hope

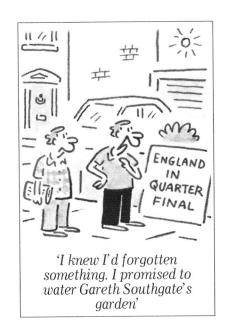

'I knew I'd forgotten something. I promised to water Gareth Southgate's garden'

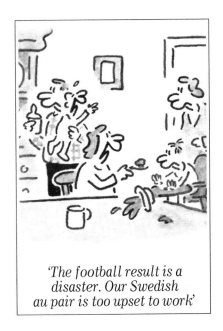

'The football result is a disaster. Our Swedish au pair is too upset to work'

England continues to win . . .

World Cup

. . . up until the semi-final

'I've come from Marathon.
Do you wish to continue
receiving these messages
after GDPR comes in?'

'It says after GDPR we
have to opt in to receive
these messages'

New data protection regulations

And finally...

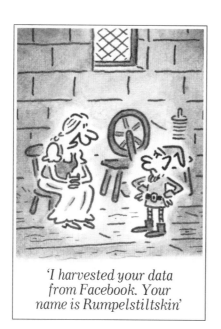

'I harvested your data from Facebook. Your name is Rumpelstiltskin'

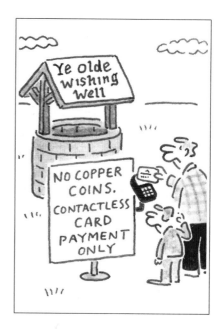

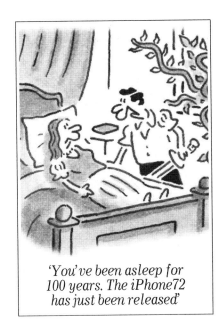

'You've been asleep for 100 years. The iPhone72 has just been released'

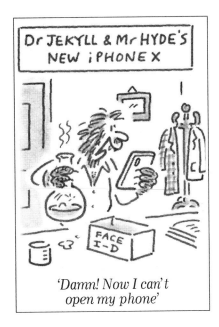

'Damn! Now I can't open my phone'

And finally...

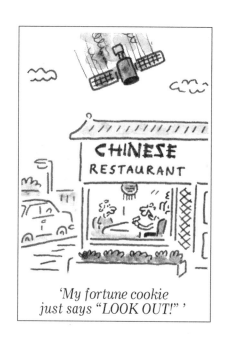

'My fortune cookie
just says "LOOK OUT!"'

Rogue satellite

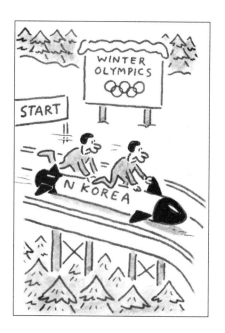

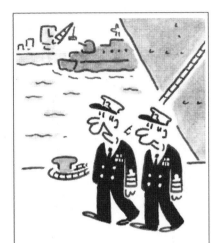

'We have no warships in
service. All that's between
us and the Russian fleet are
28 dolphins off Cornwall'

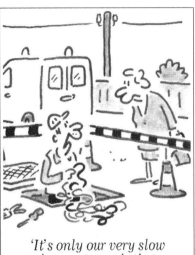

'It's only our very slow
internet speeds that
protect you from a
Russian cyber attack'

And finally...

And finally...

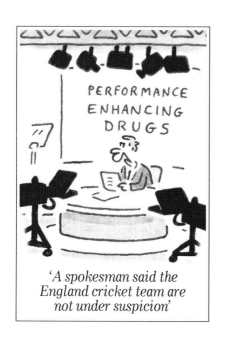

'A spokesman said the
England cricket team are
not under suspicion'

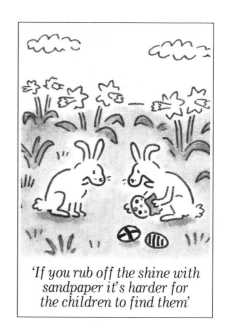

'If you rub off the shine with
sandpaper it's harder for
the children to find them'

Cricket ball tampering

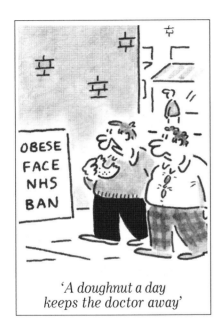

'*A doughnut a day
keeps the doctor away*'

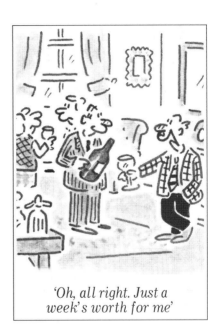

'*Oh, all right. Just a
week's worth for me*'

Health advice

And finally...

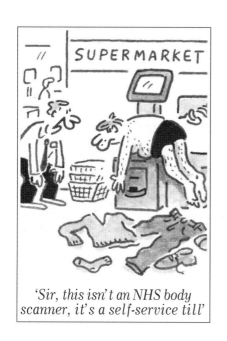

'Sir, this isn't an NHS body scanner, it's a self-service till'

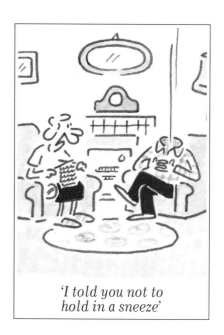

'I told you not to hold in a sneeze'

Medical advice

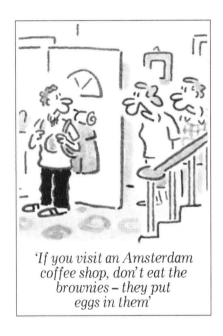

'If you visit an Amsterdam
coffee shop, don't eat the
brownies – they put
eggs in them'

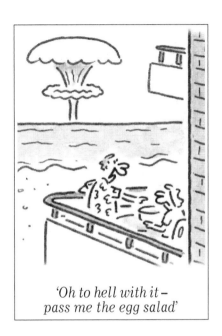

'Oh to hell with it –
pass me the egg salad'

Egg scare

And finally...

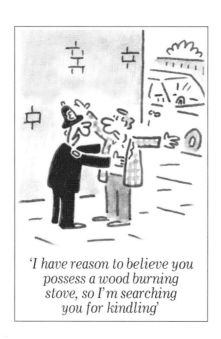

'I have reason to believe you
possess a wood burning
stove, so I'm searching
you for kindling'

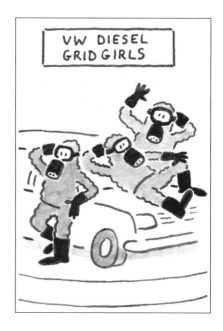

VW DIESEL
GRID GIRLS

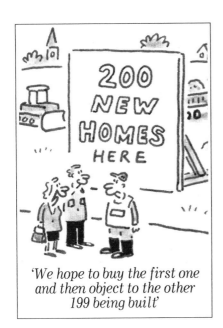

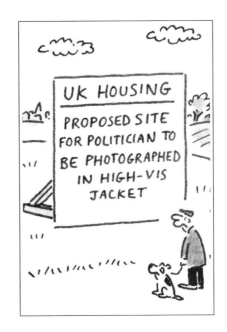

And finally...

And finally...

'I've got another job on. The Government wants me to take over the HS2 contract'

VIOLENT CRIME:
GOVT ANNOUNCES 300
EXTRA MISS MARPLES

'Would you mind telling me
how much is in my
current account?'

Technical hitch

And finally...

'That's much quieter'

'The bells ... the bells ...'

And finally...

And finally...

'E.T. not return Harvey
Weinstein's calls'

'Do you think my snowman
is happy with his gender'

Chicken shortage

And finally...

'The university has a safe space policy. We don't discuss subjects that some of us might find upsetting – like my pay'

'There's blame on both sides. The examiner must bear some responsibility'

'I don't blame the school for cheating. We weren't entirely honest when we said we could afford the fees'

'We hope to offer less privileged children the sort of first class cheating you get in the private sector'

And finally...

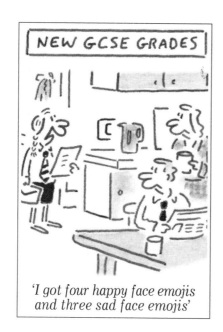

'I got four happy face emojis and three sad face emojis'

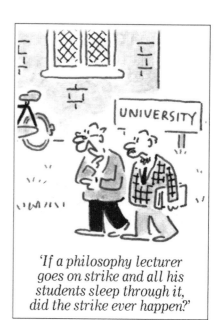

'If a philosophy lecturer goes on strike and all his students sleep through it, did the strike ever happen?'

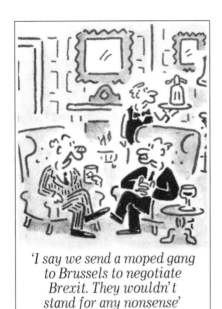

'I say we send a moped gang
to Brussels to negotiate
Brexit. They wouldn't
stand for any nonsense'

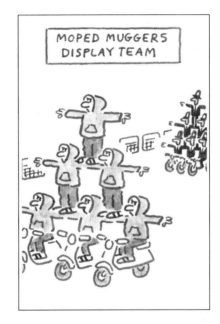

And finally...

And finally...

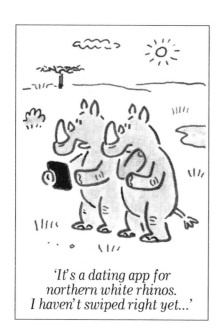

'It's a dating app for northern white rhinos. I haven't swiped right yet...'

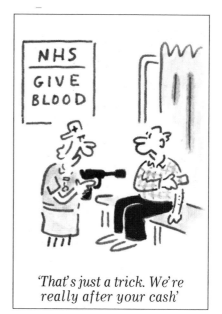

'That's just a trick. We're really after your cash'

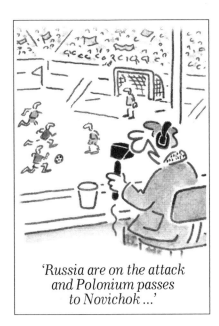

'Russia are on the attack
and Polonium passes
to Novichok ...'

'Budget crisis, troop numbers,
kit problems – if it wasn't for
the Defence Secretary, there'd
be nothing to laugh at, at all'

And finally...

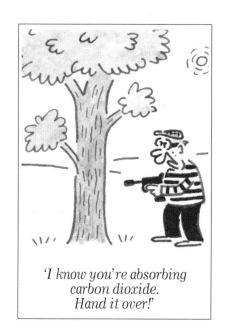

'I know you're absorbing
carbon dioxide.
Hand it over!'

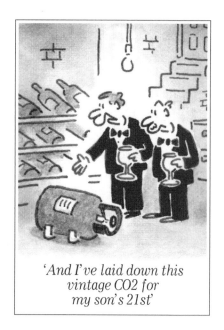

'And I've laid down this
vintage CO2 for
my son's 21st'

CO_2 shortage